D0819615

SMALL ROOMS & HIDDEN PLACES

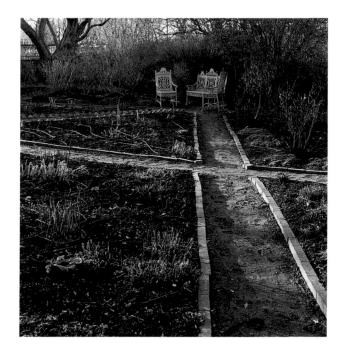

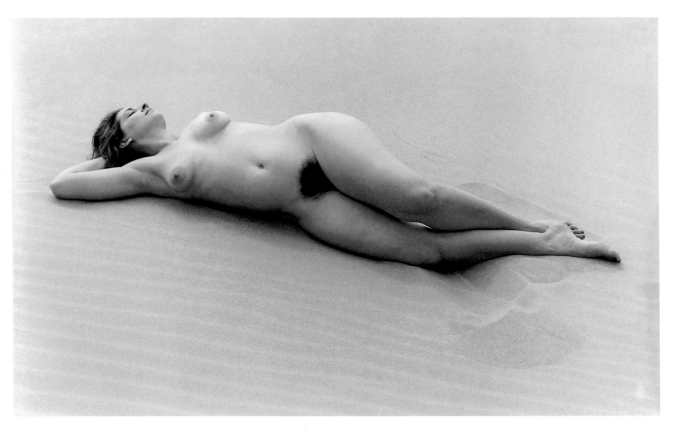

SMALL ROOMS &

photographs by Ronald W. Wohlauer

with a journal by Elizabeth Wohlauer

foreword by David Bayles

HIDDEN PLACES

AN IMAGO MUNDI BOOK

DAVID R. GODINE, PUBLISHER

BOSTON

*I am a lucky man to have
such a talented and beautiful wife
who is my boon companion and dearest friend
Our footprints are eveywhere in my photographs.
This book is dedicated wo a woman
of great style and class,
Elizabeth Wohlauer.*

First published in 2004 by
DAVID R. GODINE, *Publisher*
Post Office Box 450
Jaffrey, New Hampshire
www.godine.com

Copyright © 2003 by Ronald W. Wohlauer
Foreword copyright © 2003 by David Bayles
Jornal copyright © 2003 by Elizabeth K. Wohlauer

*All rights reserved.
No part of this book may be used or reproduced
in amy manner whatsoever without written permission,
except in the case of brief excerpts embodied
in critical articles and reviews.*

LCCN 2004103206

FIRST EDITION
Printed in China by C & C Offset

FOREWORD

David Bayles

A FEW MONTHS AGO Ron asked me to write a piece for this book. "Well, what kind of a piece?" I asked. "Anything you want," he said.

I readily agreed. Ron and I have been close friends for thirty years – all of my professional life and all of his – and I welcomed the chance to comment on his work. I did have the reservation that beyond the obvious difficulty in writing about a friend's pictures, or the larger difficulty of writing about certain pictures *at all*. It's not impossible, just difficult.

The difficulty is greatest for pictures that are not products of thinking but products of seeing and feeling. In that regard, Ron's pictures are very simple pictures, and are in fact neither more nor less than what they appear to be. They do not carry intellectual burdens, they do not make arguments, they do not comment on art. A great many artists of the twentieth century decided that art and art issues are the proper subject matter of art but they failed to convince Ron.

In the face of such wordless pictures, there is a temptation to talk about the work by talking about the artist. Fair enough. If the life of the artist and the qualities in the art are connected, then talking about the artist may be more than gossiping it may actually have something to do with the pictures. And in search of the artist, it is tempting to look to an artist's origins, to their ancestry, to their geog–raphy. Try it. Picture, if you can, European refugees with heavy accents and advanced educations settling in rural Colorado in 1939. Picture, if you can, what kind of artist arises from the improbable combination of old European roots and new crossroads – Colorado–before–the–boom. What kind of artist comes from that place?

The answer is: any kind of artist at all. In the later half of the twentieth century, neither geography nor genealogy nor anything else is destiny. In the twentieth century, artists create themselves out of whole cloth wherever they are and whoever they are. They invent themselves, as Ron has, or they do not exist.

Ron's work, seemingly the work of tradition, is in fact like most twentieth-century work really the product of tradition-by-choice. The work is made when an artist voluntarily reaches out across time and distance to associate himself with selected fellow travelers, with communities of the mind, with compelling subjects, with particular ways of making pictures, with certain ways of being an artist. In a culture that has no serious role for art or artists, those who would be artists need to make choices that are very sustaining. Artists *chose* who they are going to be, and if they don't, they don't become anything at all. This is the weakness and the strength of the place we have made for the arts in our culture, and Ron has made his peace with that.

Since it is all by choice, it could easily have been different. Early in his photographic development, it was possible that Ron thought he was in line to inherit a genuine tradition. In the late 1960s, the West Coast School of landscape photography showed hints of becoming a real tradition.

The Ansel Adams and Edward Weston generation was being succeeded by a second generation of similar artists, including Brett Weston and Morley Baer, who were Ron's senior advisors and his friends. Ron learned his craft direct from the masters, in the tradition of learning arts when there were traditions in learning art.

But a real West Coast landscape tradition has not evolved. Perhaps real traditions need real communities; Ron was on his own to figure out how to make work that mattered and a life that mattered. He settled on work that is dense, somber, wordless, simple, and direct.

He settled on a life that is as simple as possible: a brick house, a border collie, a cat, three kids, two marriages, one divorce. I think there were fish, too, for a while. He settled on a persona to compliment the work; hats, vests, bush jackets and little round glasses. He smokes a pipe and writes with a fountain pen. He works in obsolete versions of black and white, uses cameras that are no longer made, and develops his pictures by hand in solutions so obscure the ingredients have to be special ordered from virtual alchemists. As all artists know – you use what it takes.

But really Ron created this work by creating a life where picture making is the taken–for–granted centerpiece of life, and where a continuous stream of new pictures is a necessary part of living. I am not talking about persistence. I am talking about a life that revolves around pictures that are personally meaningful and evocative – without which persistence would be idiotic.

What you hold in your hand then, is an outcome of unending choices about making pictures and about living a life and about how those fit together. They are pictures that come from the seldom–articulated premise that things can be what they appear to be, and that a life organized around such pictures is a life worth living.

THE BRITISH ISLES

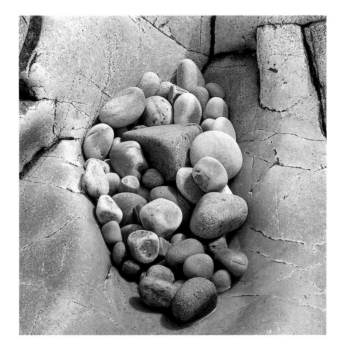

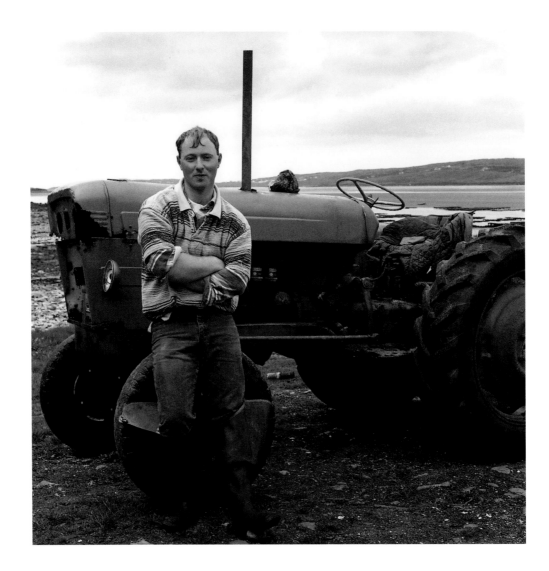

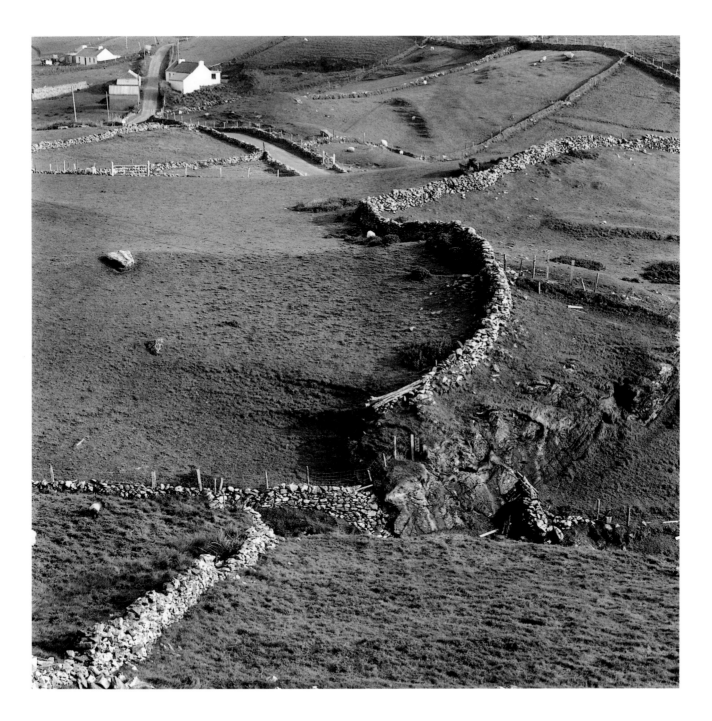

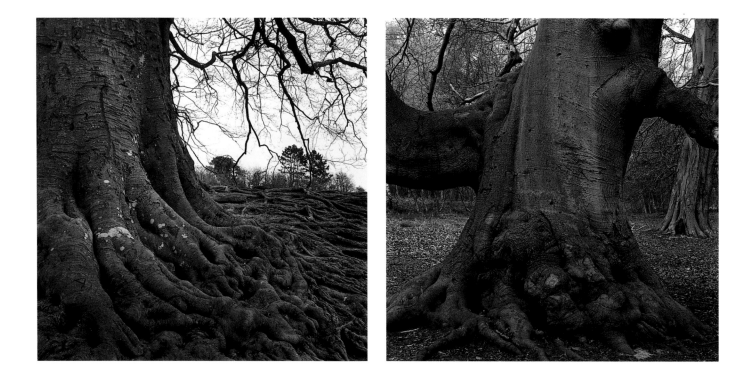

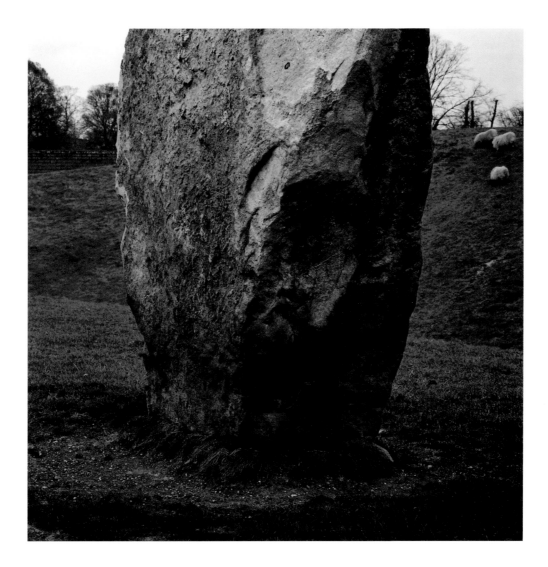

JOURNAL

Elizabeth Wohlauer

The Standing Stones of Callanish
Isle of Lewis and Harris, Scotland

Ron has been telling me about the Standing Stones of Callanish ever since we met. And now here we are. Not an easy place to get to, though it doesn't look too far on the map. From Edinburgh it took two and a half days to go up through the Highlands, across to the Isle of Skye and the port of Uig. Then a two–hour ferry ride across the rough and foggy North Atlantic to the town of Tarbert. I've never felt so far away before. It's another world here, one of sharp winds, rough rocks, hardy people and tiny roads as often used by sheep as cars. It's wildly beautiful in a melancholy sort of way. I felt I'd gone back in time.

At Callanish I walked around for awhile with my camera looking at the Stones, not finding any way to make visual sense of them. Ron was very quiet. I walked over to him, startling him out of his reverie. He said, "I just hope I can do this, the wind is blowing so hard." Indeed it was. I wasn't getting anything but cold so I turned toward the visitor center and left him there, gripping his tripod to keep his camera upright, occasionally ducking around a Stone for shelter, focused and intent. Inside the visitor center it was cosy and warm. I got a cup of coffee and a piece of chocolate cake that was too big for even me to eat. Hours later Ron blew in, raw and frozen. I asked how it went, he shook his head with a grin and said, "I don't know if I got anything but I love this place."

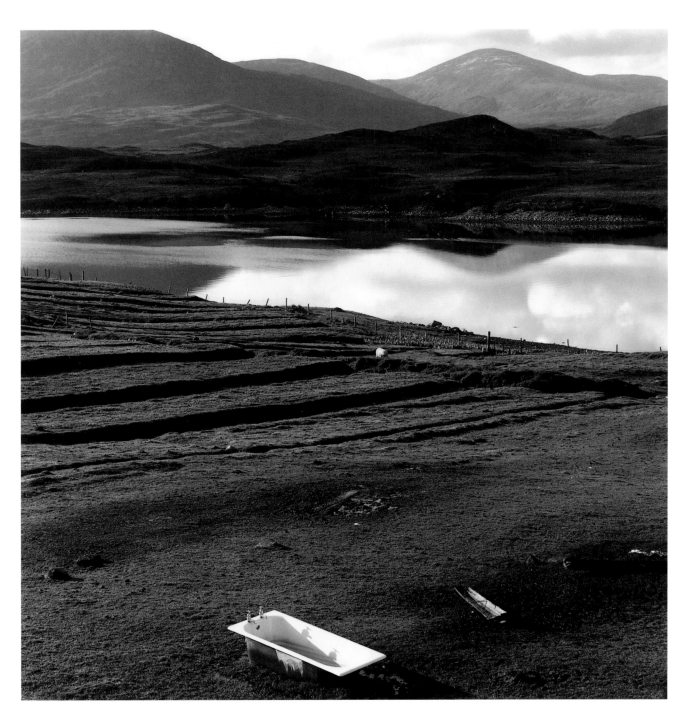

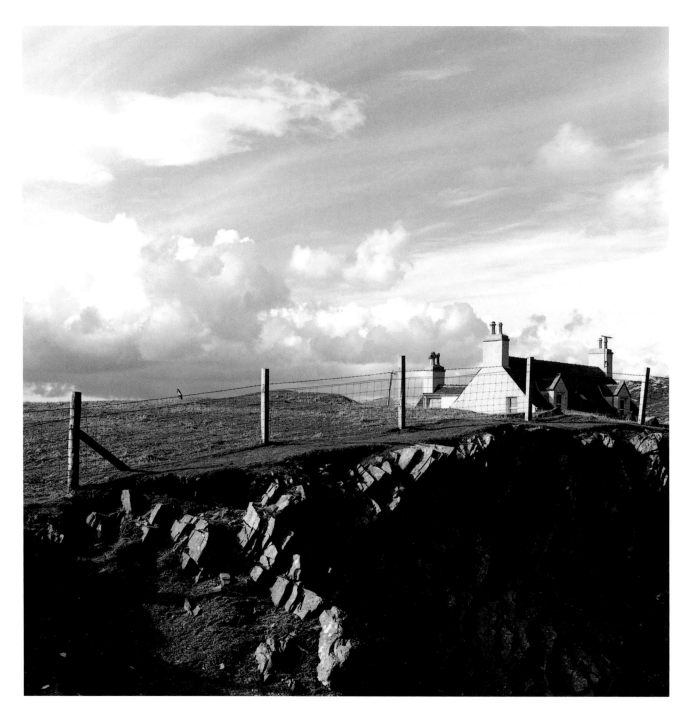

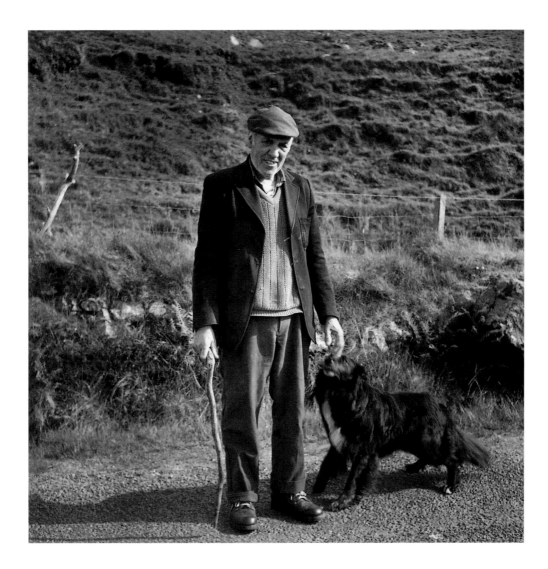

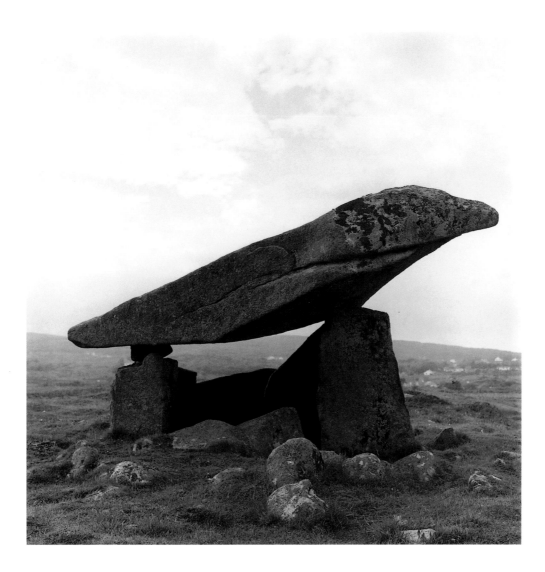

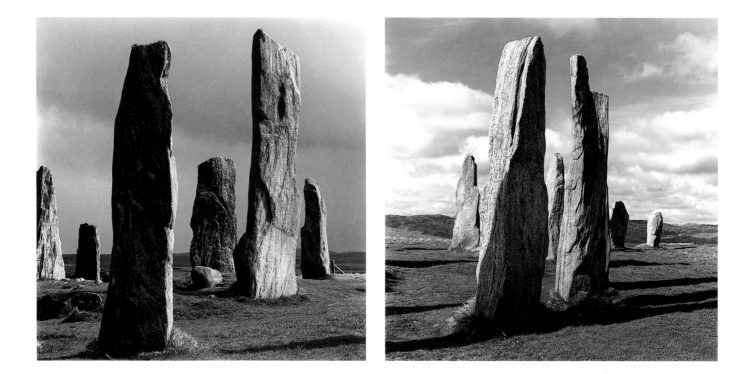

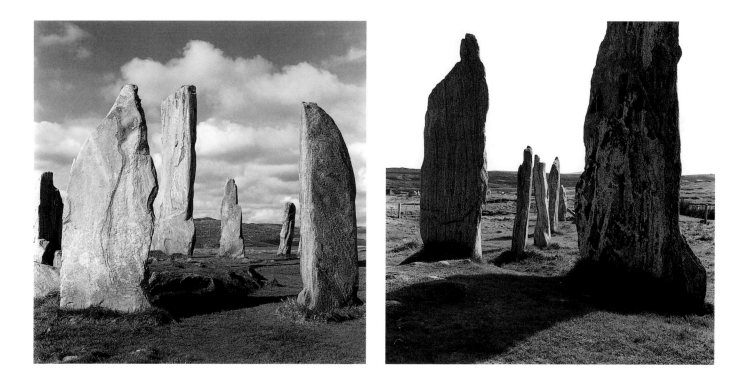

KILCLOONEY
County Donegal, Ireland

RON HAS a dazed look. Maybe it's the late nights at Peter Oliver's pub listening to his beloved Irish music. Perhaps it's five weeks on the road photographing to his heart's content, or it could be he's really lost this time. Tired and a little lost that's us.

We are in the most Gaelic part of Ireland, the most remote, proud and private part of Ireland. I love Ireland. I love its contradictory ways. But it's being rather too contrary now. We keep going up the road we've been told to go up and still can't find the "wee road" describe to us as the turn off to the portal dolmen Ron wants to photograph. The only road that looks likely enough leads to a house. Again we head back to town for directions. This time the boys on bikes take pity on us and agree to lead us – to the very same spot. How could this be? This is an important site at least for dolmen aficionados like us. Yet there are no signs, billboards, curio shops or anything whatsoever to indicate that a Place of Special significance is right up the road. We did go up the wee road and sure enough, there's a house at the end. An older man came out, napkin in hand, we had obviously interrupted his supper. We were in the right place and though this man must have had dozens of meals interrupted by tourists, he was gracious. Telling us to leave our car and to be sure to close the gate behind us, he went back to his supper. We walked through the green pasture, marvelling at the kindness and patience of the Irish. The dolmen was beautiful – worth all the confusion. I looked at Ron, standing by his camera, contentedly smoking his pipe. I suddenly felt an overwhelming desire for us to be safe indoors with a dog at our feet and a cup of tea in hand. So we headed back down the hill, careful to close the gate behind us.

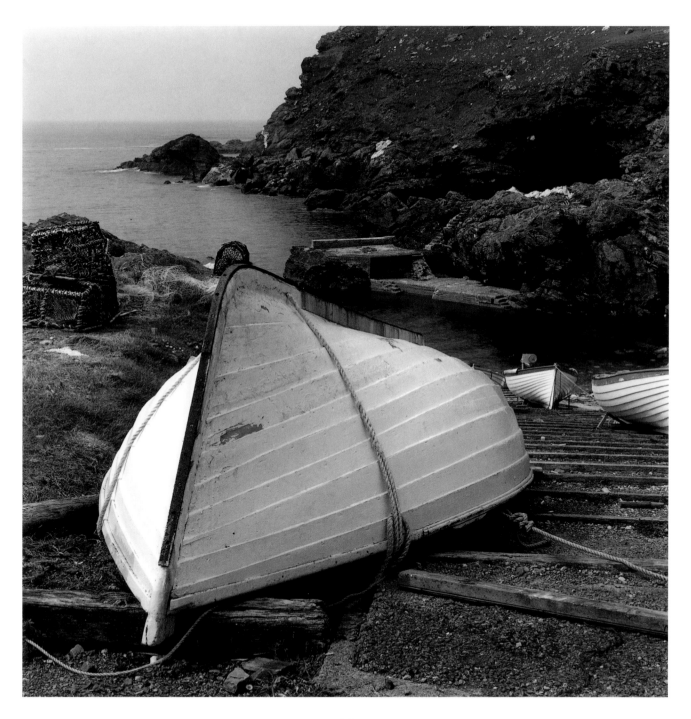

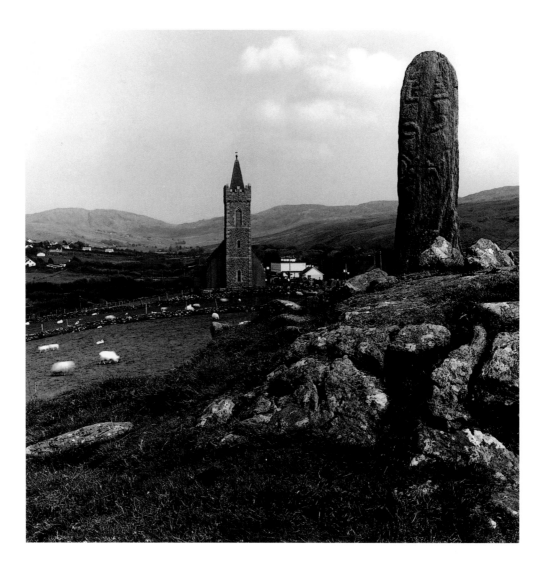

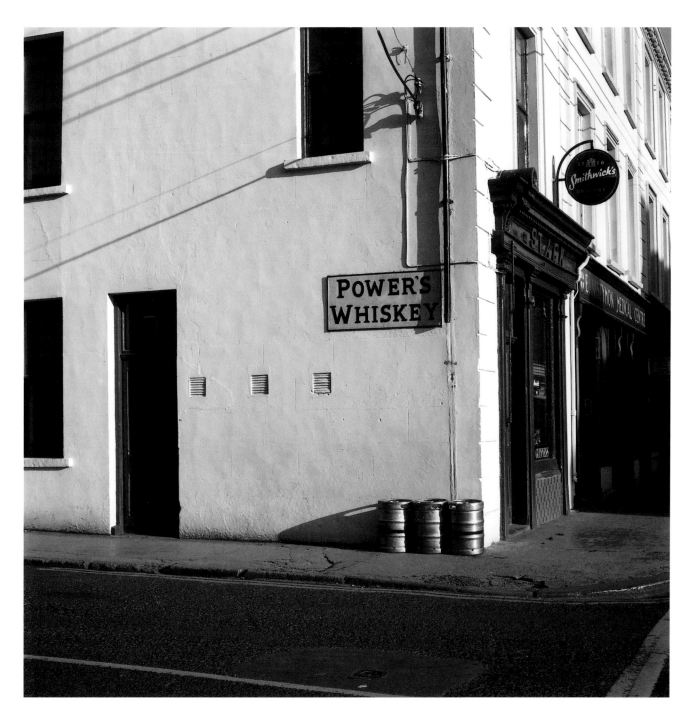

LACOCK ABBEY
Wiltshire, England

RON AND I are riding in the back of a small car. In the front, sit Simon Emerson and his wife, Cathy. Simon drives while Cathy, with a book of maps on her lap, gives directions. We go this way, we go that way, we go this way again. These roads are very narrow and we seem to be going very fast but to where Ron and I do not know. It's a surprise.

This visit to Lacock Abbey was a gift to Ron from his Cambridge school chum and genuinely lovely person, Simon. I can tell by my husband's demeanor that this place is more than just an historic manor house that used to be an abbey. As I soon find out, this was the home of William Henry Fox Talbot who was the inventor, in 1840, of the negative-positive method of photography. The man who made the first negative. It's why we are here – to make lots and lots of negatives!

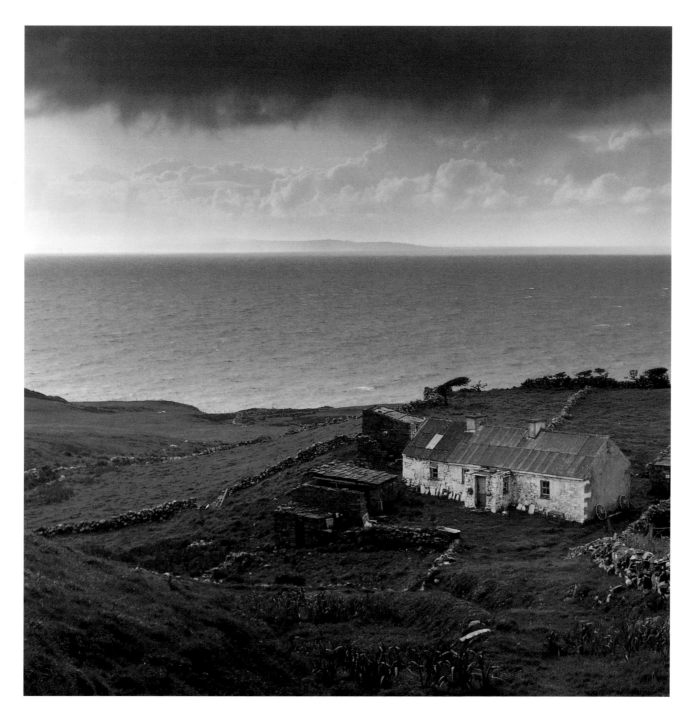

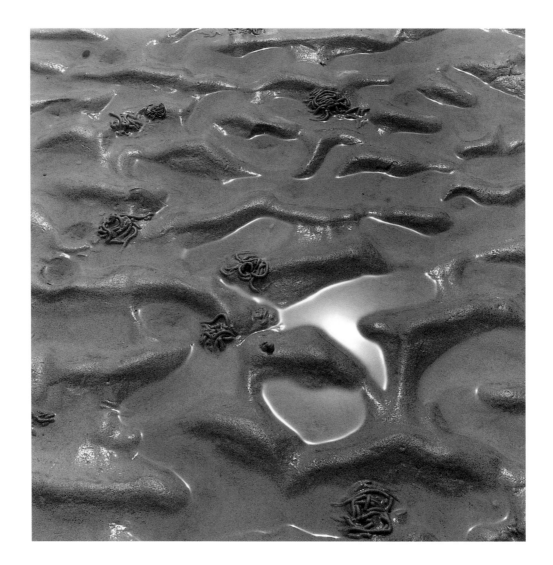

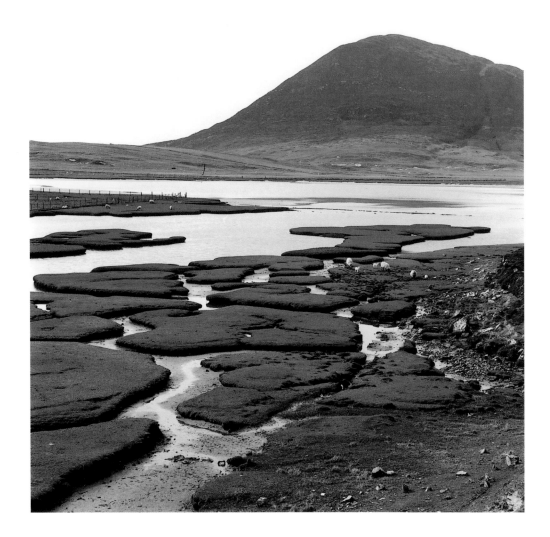

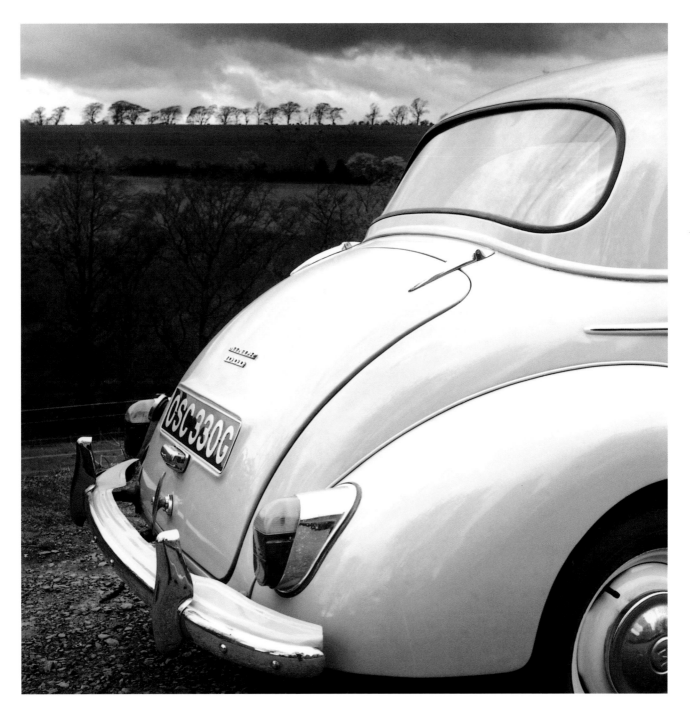

FOUNTAINS ABBEY
North Yorkshire, England

WE'VE HAD such fine weather up to now that a soft English day is welcome. The north of England is so picturesque that I expect to see a film crew around every corner. We were at Fountains Abbey today and even though it was raining I think Ron probably made some good pictures.

As we walked down the path, through the trees to the abbey, we saw before us an eerie sight. Little figures, dressed in pale brown cassocks, with hoods drawn over their heads gathered in the mist below. The little figures turned out to be schoolchildren learning a very practical lesson on what life was like as a novice monk in the eleventh century. As Ron and I walked the extensive grounds of this fabulous ruin we would occasionally come across slight figures silently walking, double file, with their hands properly together. Once we found them standing in the roofless nave of this once great Cistercian abbey singing the *Ave Maria* in Latin. It was lovely.

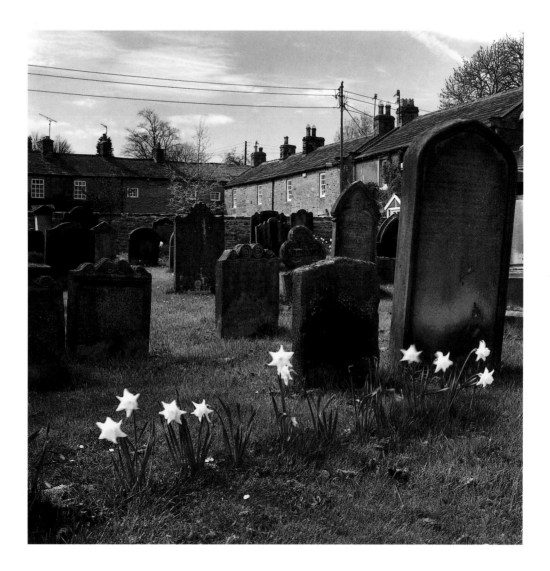

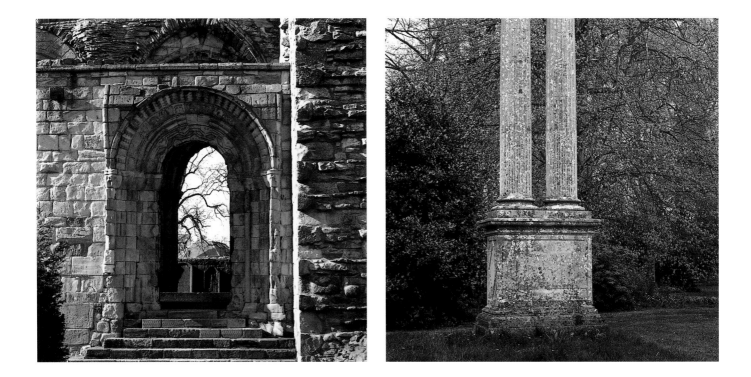

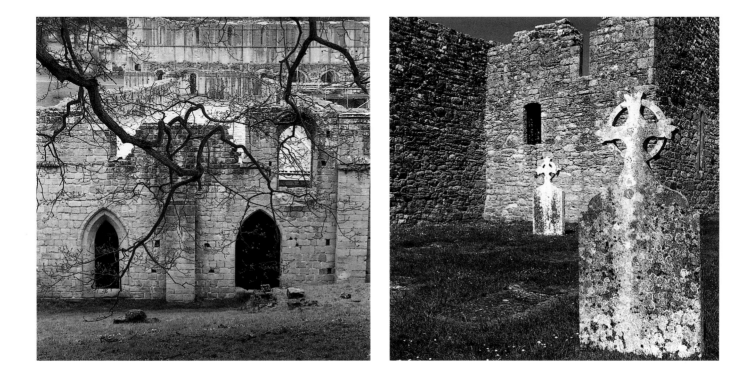

MOUNTAIN WEST

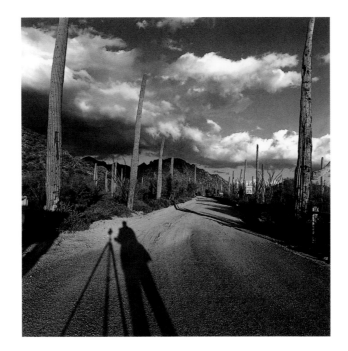

Alabama Hills
Lone Pine, California

LOTS OF OLD MOVIES and TV shows were made here. *Death Valley Days, Bad Day at Black Rock, High Sierra, The Lone Ranger* to mention just a few. The hills are situated at the base of Mt. Whitney, the highest mountain in the lower forty-eight states. All around is desert, thanks to Los Angeles draining all the water from the Owens Valley leaving it high and dry. But I like it here. The Hills are concentrated in a few square miles just outside of town. Huge, rugged, eroded mazes of granite, with tiny dirt roads darting off here and there. Spent most of yesterday trying to figure out what movie was made where while Ron photographed. This morning we got up early, Ron threw a dress over my head, and took me to the Hills for a spell of daybreak modeling. I was sleepwalking until my dress came off and I sat on the rocks – talk about rough! I'll have indentations on this poor sleep deprived body for weeks! I was cooperative for about fifteen minutes before I balked – complaining of the blinding sun, the sharp rocks, and my desperate need for coffee. Like a film director of old he bullied, cajoled and ignored my pleas. Finally he finished and said, "This may be the best nude of you I've ever done. Ready for breakfast?"

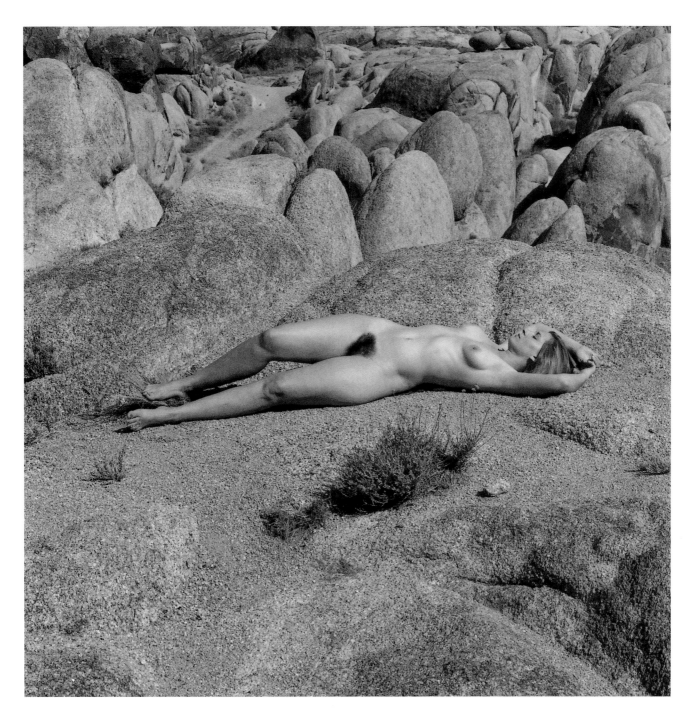

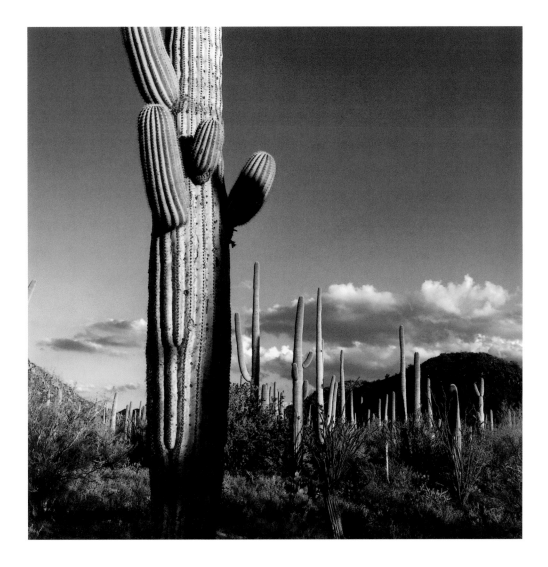

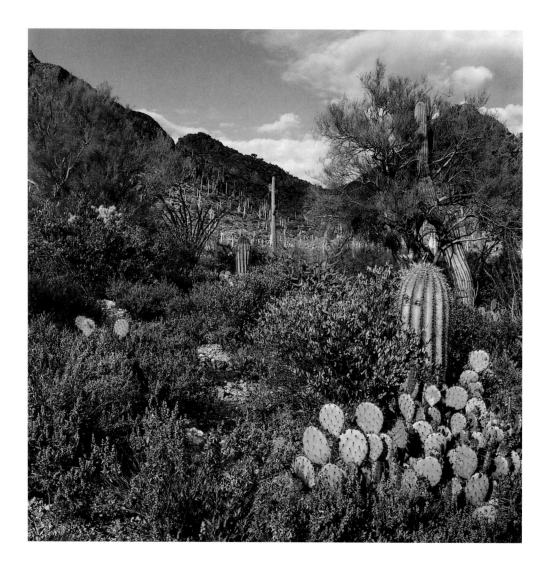

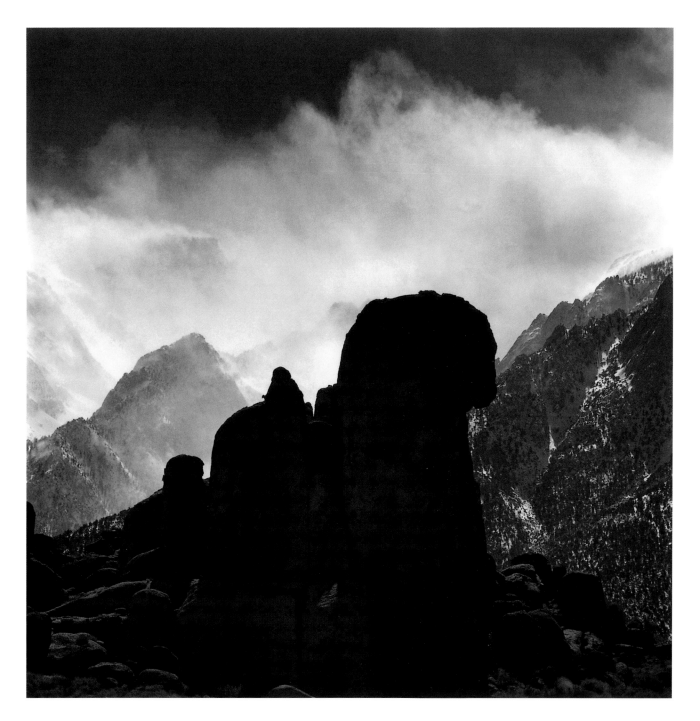

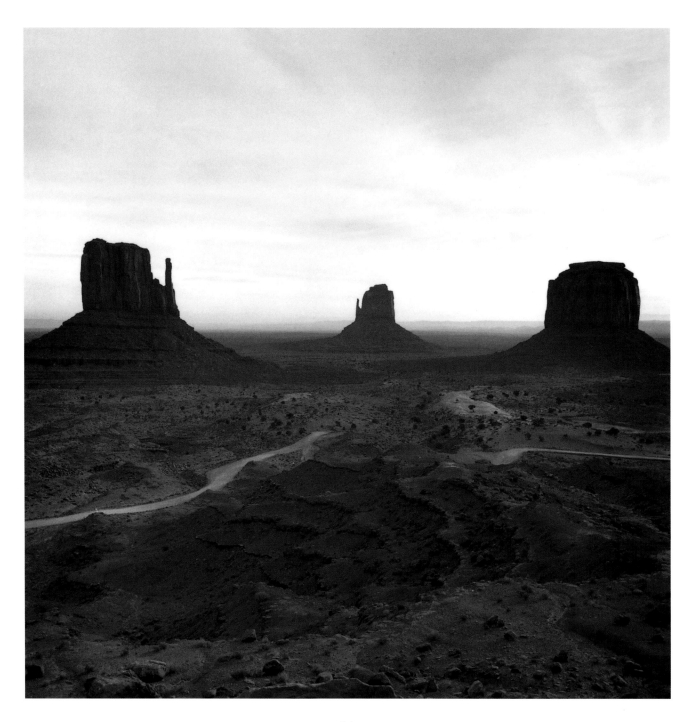

44

WHITE SANDS
Alamogordo, New Mexico

ALAMOGORDO WAS A dusty ranching and railroad town until July 16, 1945. On that day, the first atomic bomb was detonated north-west of here. Now it's a company town – that "company" meaning the U. S. Air Force. So lots of people from all over the world come there to work on missiles and other strategies we're not to know about, which makes for a very diverse group of people roaming around what should be a real backwater of a place. Ron came through here years ago and made a beautiful picture, *Black Fence*. In it the evening sky and an old wire fence are reflected in the still waters of a shallow, soon-to-be-gone lake. We went and looked at the place. It was just a shadow of its former self.

White Sands – I expected it to be like beach sand but it's not at all. The dunes are very high and as white as snowdrifts. One road leads through this maze. There were four of five particular dunes Ron liked and he went back to them numerous times over the next few days. They were off the beaten path; beautiful, sweeping, high dunes with the dry Tularosa mountains visible to the west.

Once you are beyond the second or third dune it's easy to get lost, which is why it's good to have a dog along. Rita (our Border Collie) is able to find the car with not trouble at all. We'd say "Rita! Let's go!" And she would run ahead, stopping every so often to look back to see if us slow pokes were coming along, absolutely confident of where she was going. Without Rita we would still be wandering around under the blue New Mexican sky.

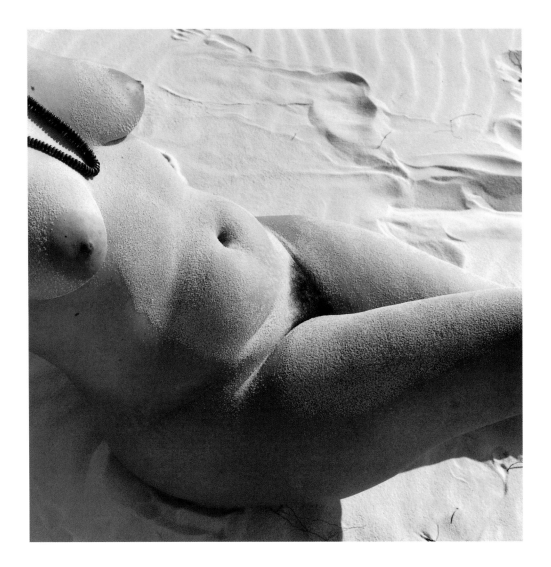

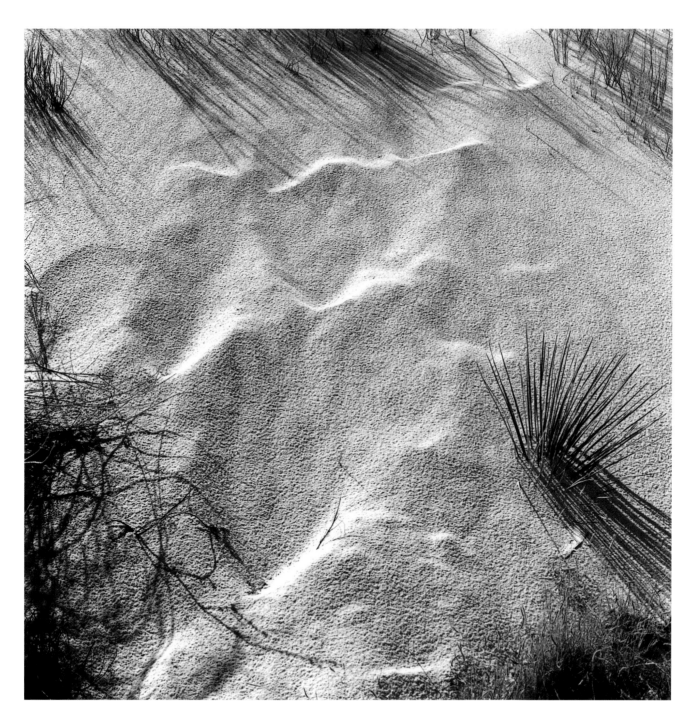

47

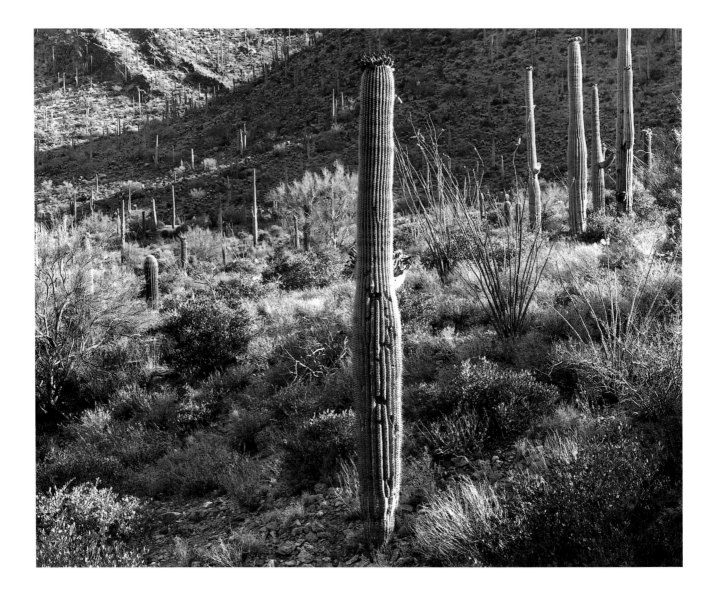

48

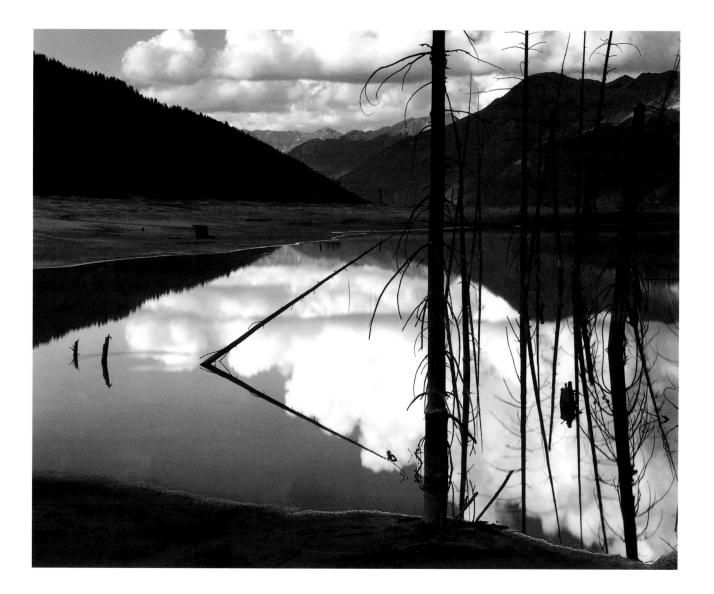

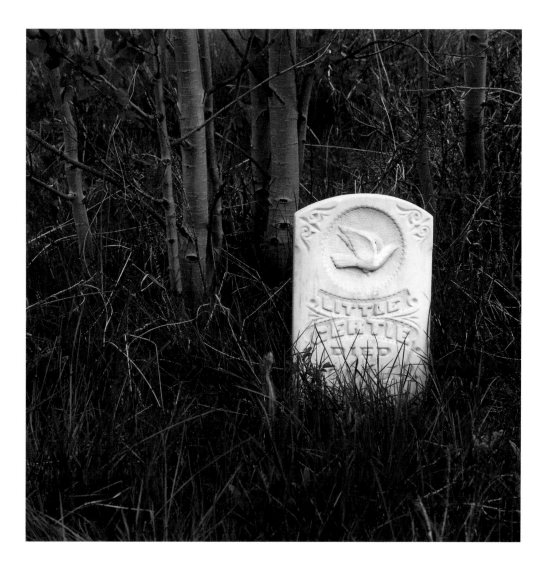

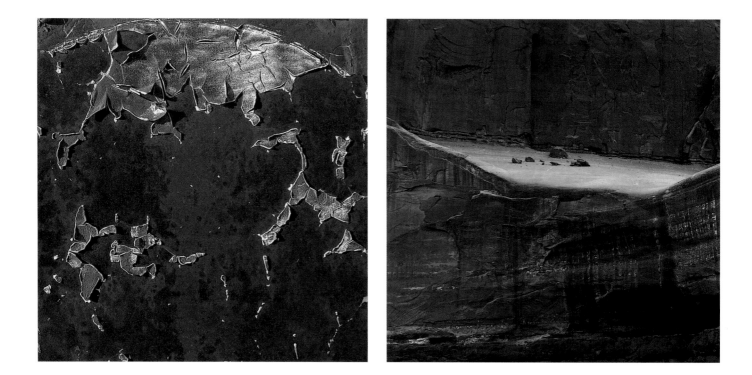

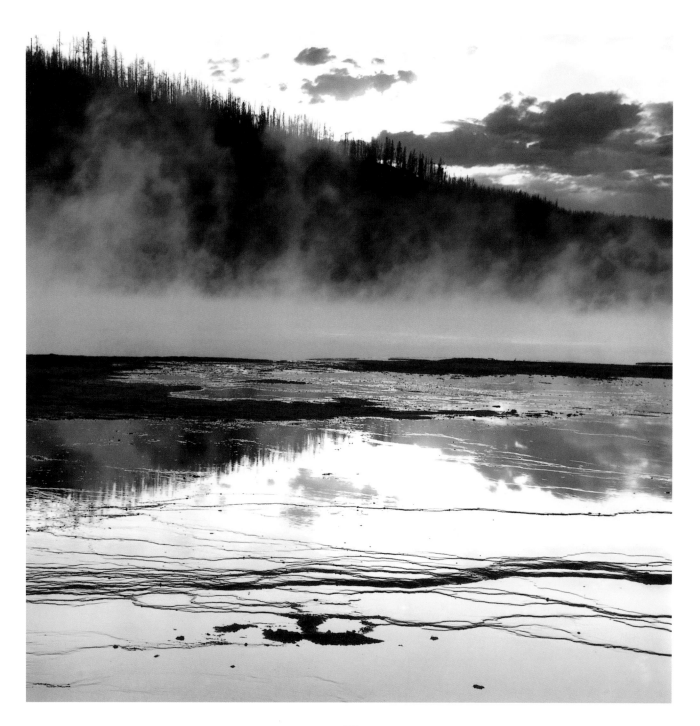

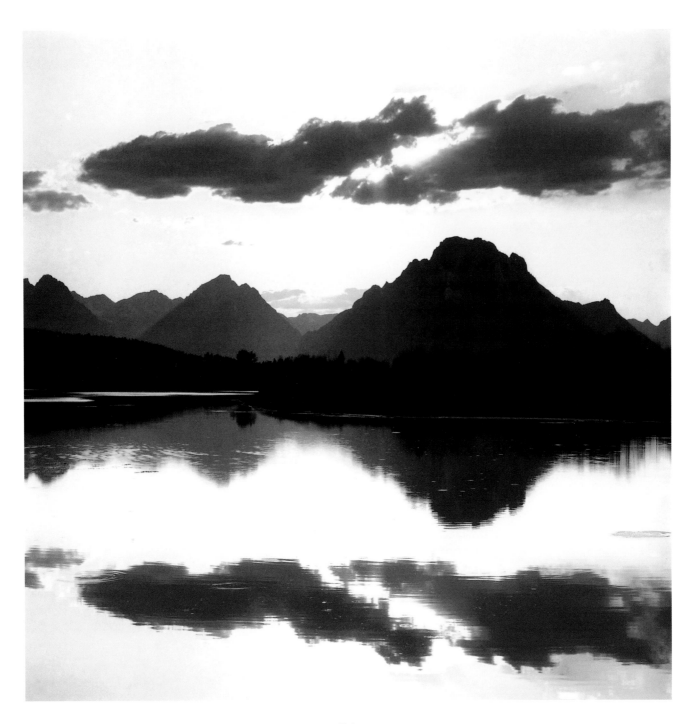

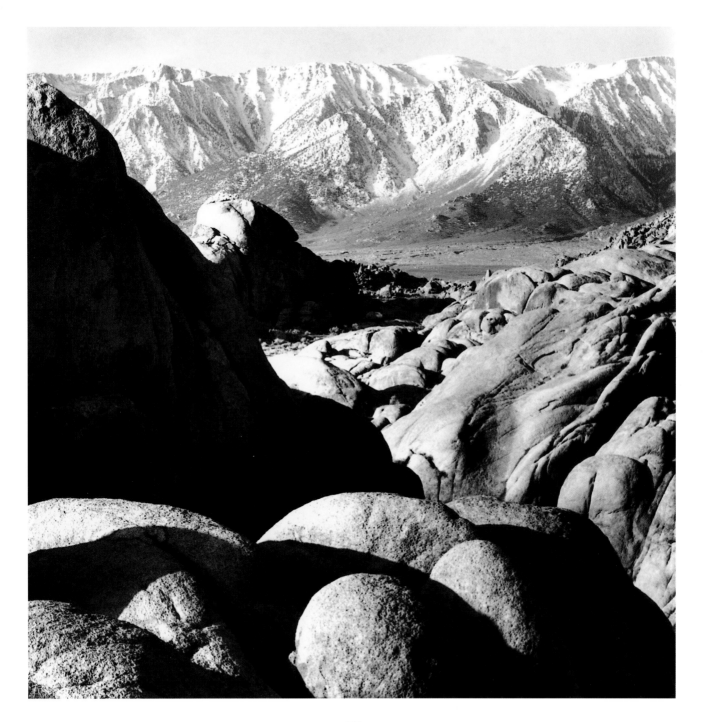

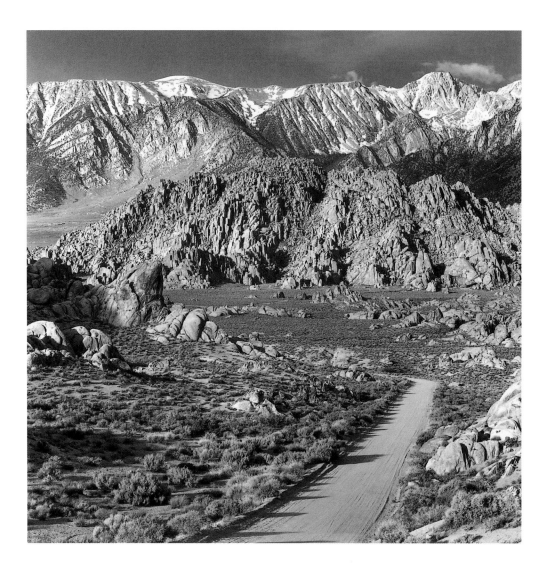

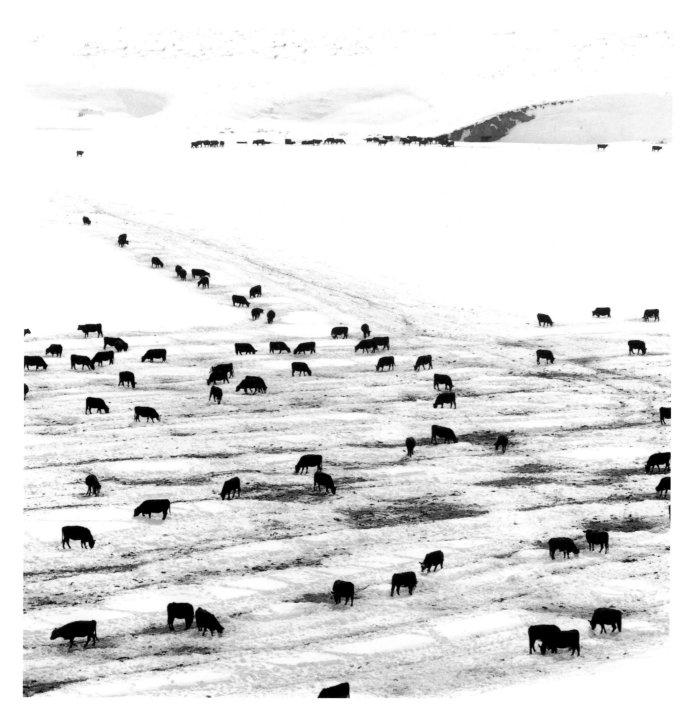

WEST COAST

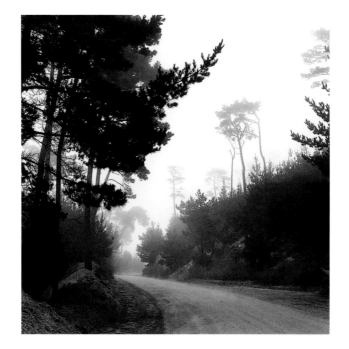

Garrapata Beach
between Carmel and Big Sur, California

LAST NIGHT there was a big storm out at sea. Now the sky is the clearest blue, the light is soft, though the surf is still pounding the beach with an awesome ferocity. Ron was so excited to introduce me to this, his favorite place, that he brought me here last night in the pouring rain to say, "Garrapata Beach is right down there. You can't see it but you sure can hear it!" But now in the late afternoon light I can see why he loves this place. The beach is long and wide with large jagged rocks buried in the surf, now appearing, now disappearing with the tide. Little creeks make their way down from the headlands to the sea. The waves are very unpredictable, sometimes just lapping at the shore, other times crashing so hard it feels like an explosion.

Ron is in heaven. He set up his camera to photograph the water and the rocks. I watched him become more and more absorbed in his work, oblivious of everything outside of his viewfinder. Including incoming waves! He must have felt his feet getting wet yet still he stood there, crouched over his camera waiting for the perfect moment. Wave goes out, another comes in, still he stands in place. Over and over the waves lap at his feet. He pays no attention. But now comes another, this one is a bigger wave and swamps him up to his knees. He stays rooted to the spot and lifts the camera high, out of harms way, waits for the water to recede and sets it down again. Ron lights his pipe and looks out to sea. His footprints have been washed away and it looks as though he is as much a part of this landscape as the rocks themselves.

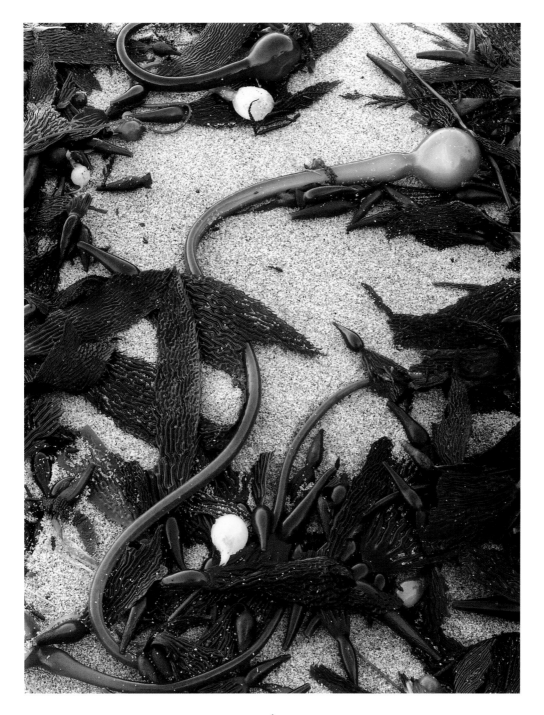

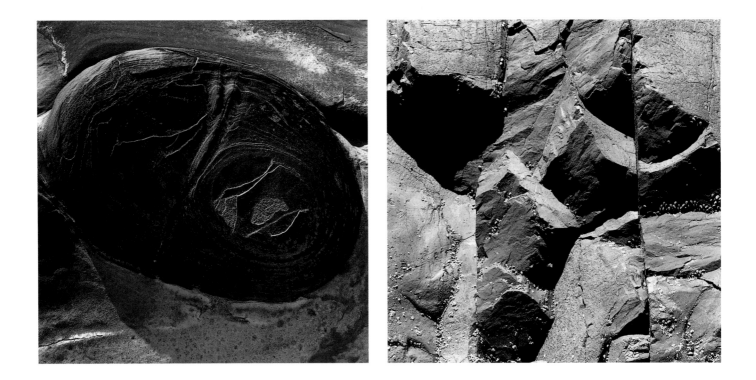

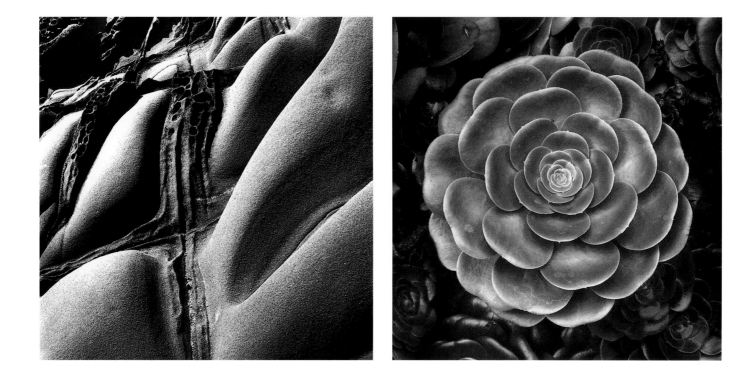

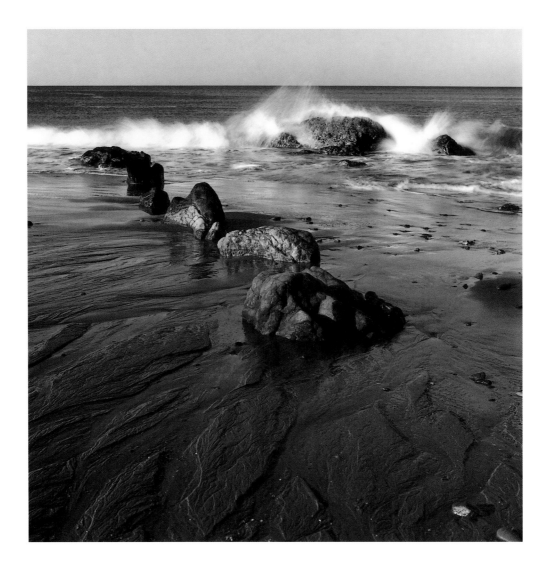

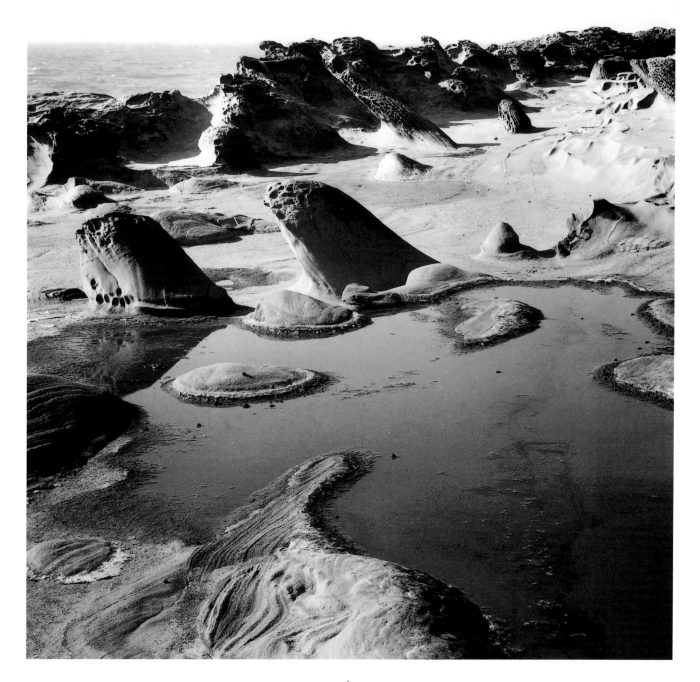

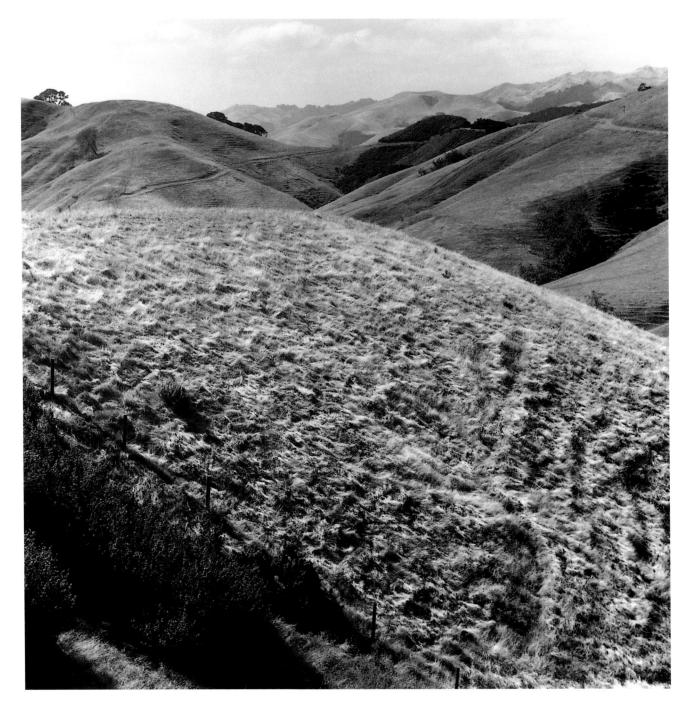

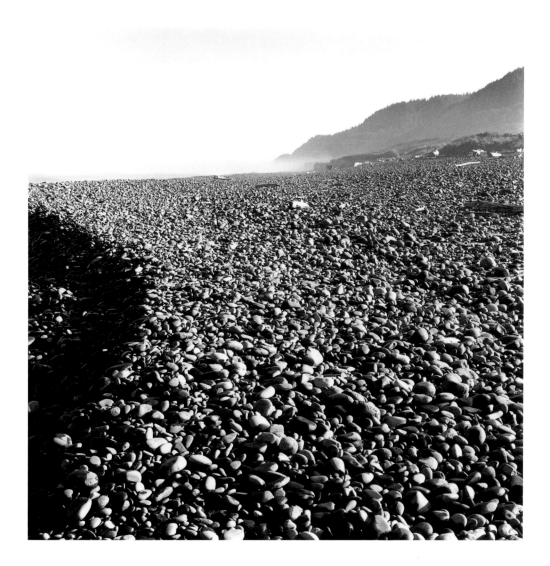

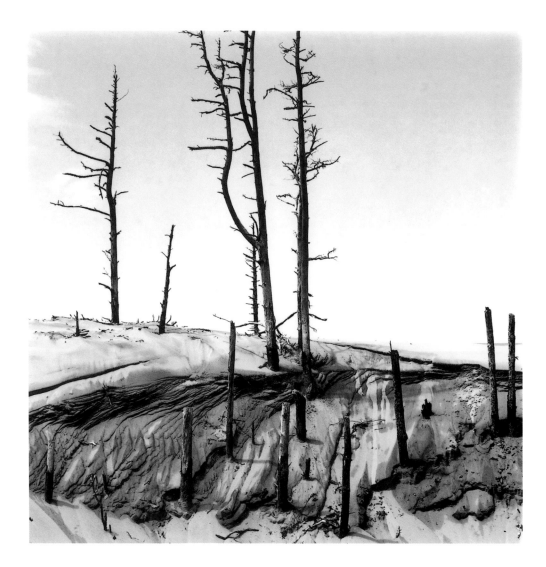

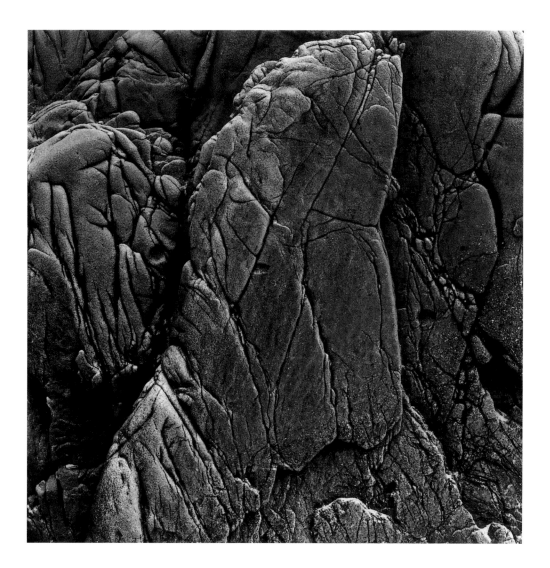

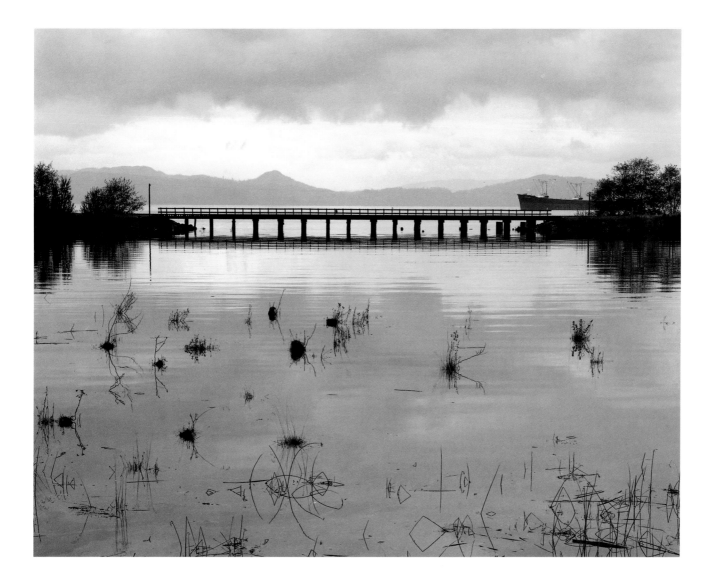

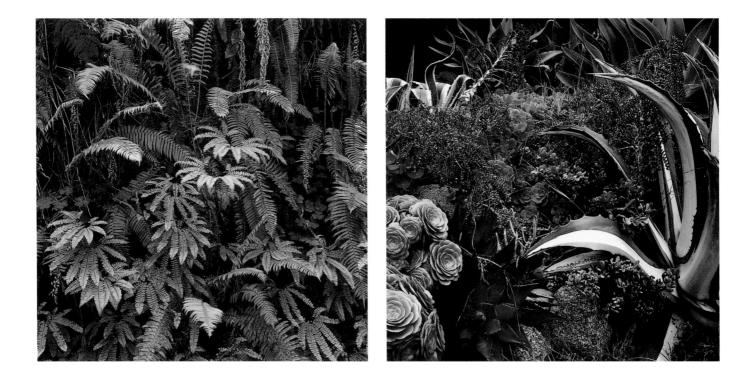

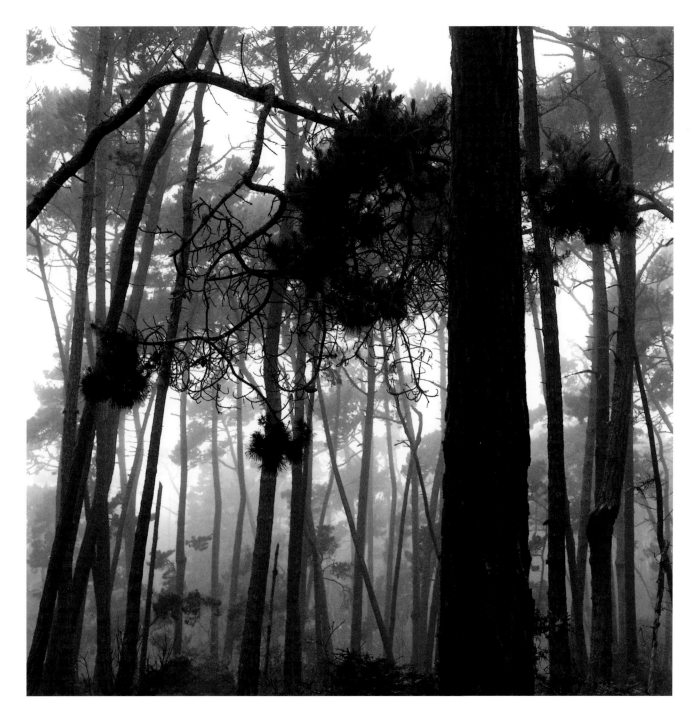

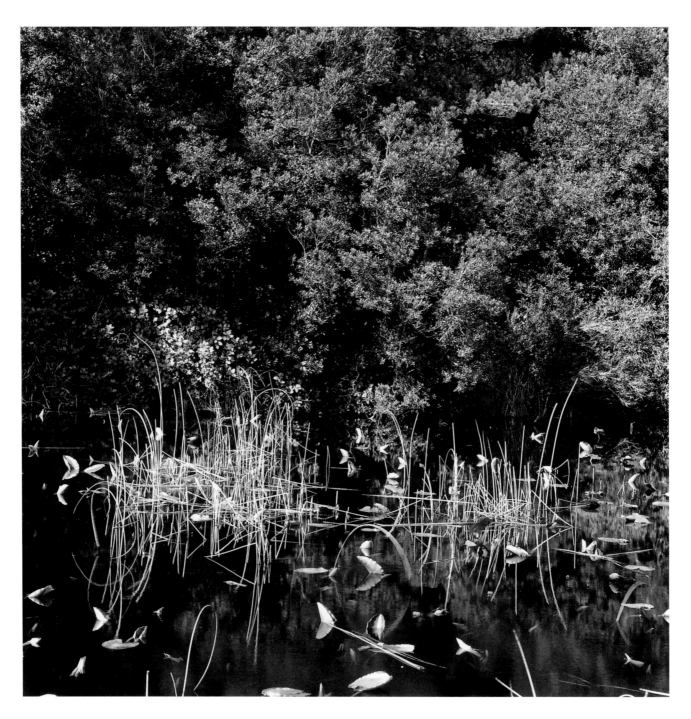

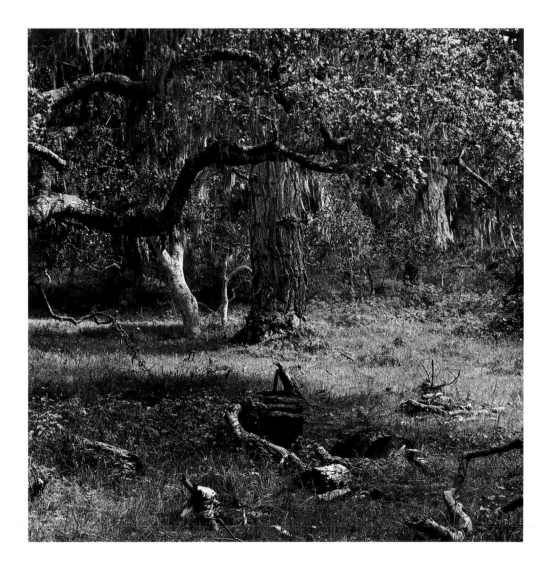

STUDIO

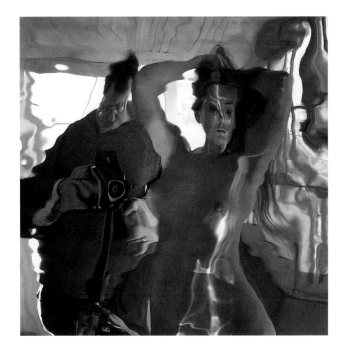

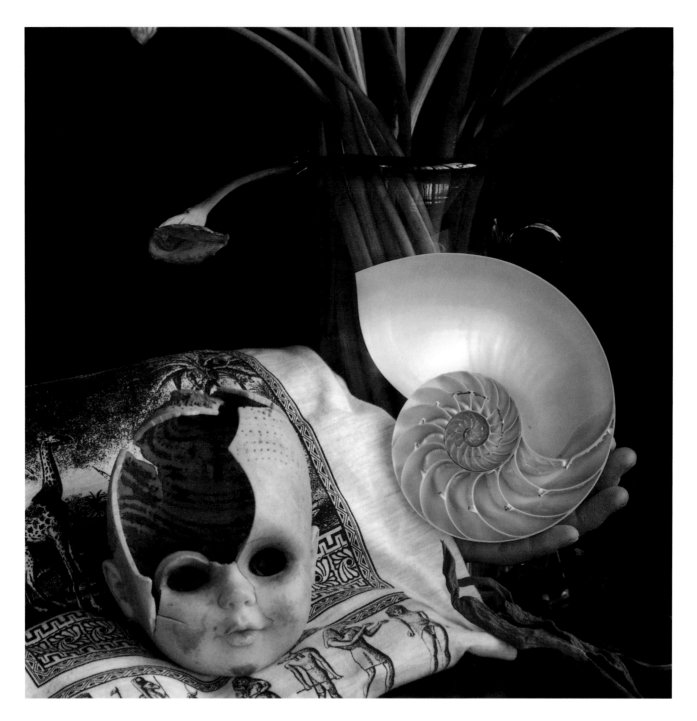

It's not a studio – just the second floor sunporch. Tiny really, room for a couch or a chair and table. Hardly enough space to bring in a camera and tripod. Windows to the north, east and south. The cherry tree has overgrown the south side giving the room a soft underwater feel. It's cold in the winter, hot in the summer but light and airy always. Even though it is so exposed it feels private and intimate.

When I first sat for Ron I wanted to look at him and I wanted him to look back at me, to make eye contact. But he wasn't there; he was always looking down into the camera and fiddling with the knobs. So I would look at him through my side of the camera and then the seductive power of the box pulled me in. I was like Alice tumbling down the rabbit hole. Now I would have the chance to explore that mysterious other world in the mirror.

Sometimes when I pose for Ron I detach a bit and just follow directions. I sit, or stand, lay down, turn around, whatever he says. Eyes open, eyes shut. Arms up. Now down. Look at me, now look to the left. That's good – hold it. Great, just one more, always just one more. But it's not always so easy. My feelings about my body are ambivalent and complicated. I have sat for Ron and felt heavy and flat. I have sat and felt lusciously round and just right. The camera captures forever those ever changing and fleeting moments. And now there are boxes of pictures of me feeling all sorts of ways.

I used to balk, and sometimes still do, at having my picture shown. It can feel too personal, too revealing. As time has gone on I've simply gotten used to it. When I would fuss about it Ron would say that someday I would be happy that we did these photographs. And that has turned out to be true. I now find it interesting to look through those boxes with a more objective eye. I have some favorites, one of them is the portrait Ron took of me shortly after we met. I remember exactly how vulnerable and yet secure I felt in his gaze.

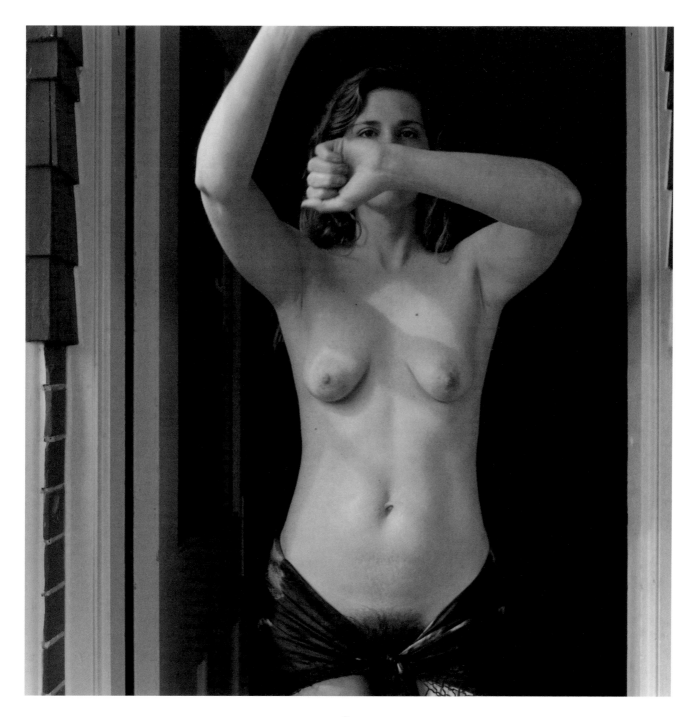

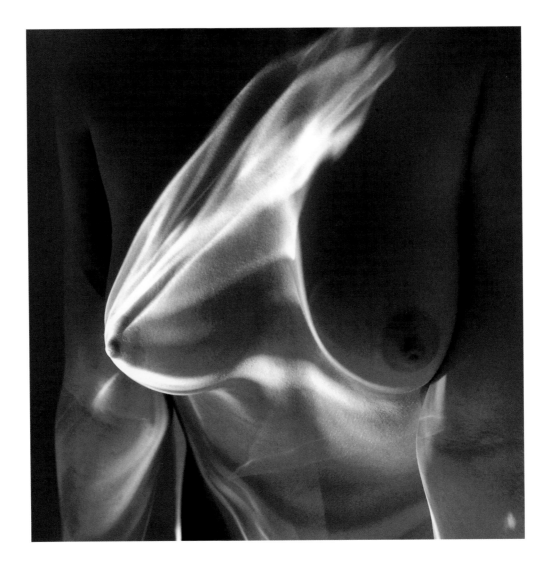

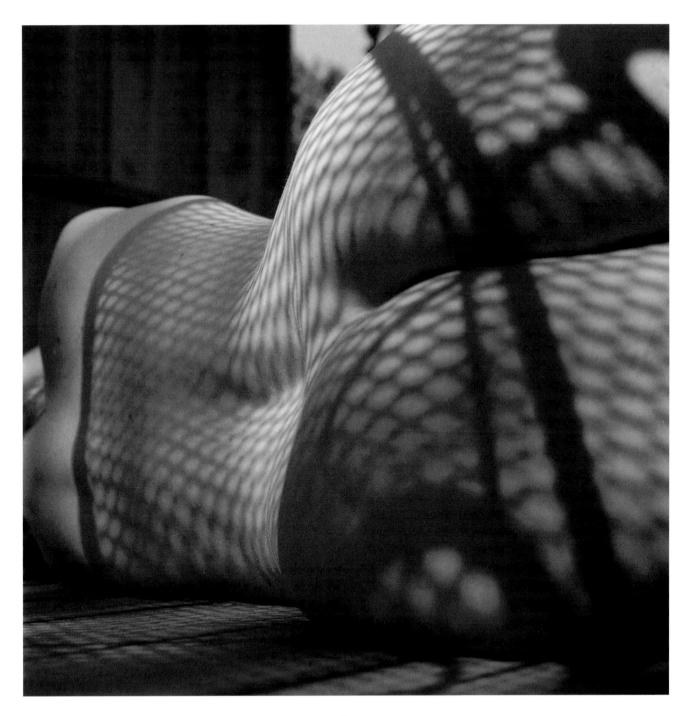

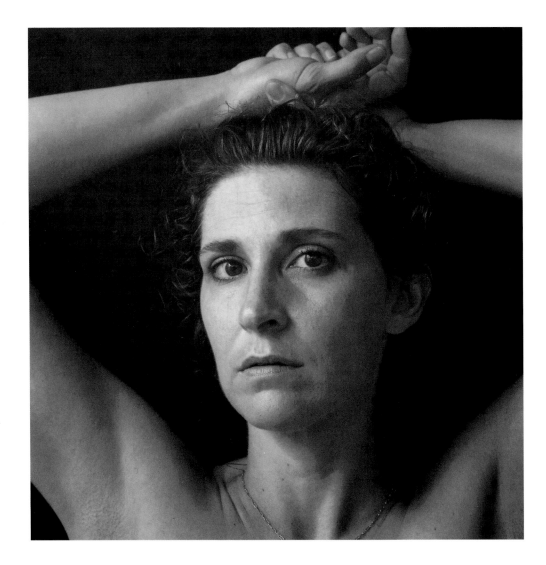

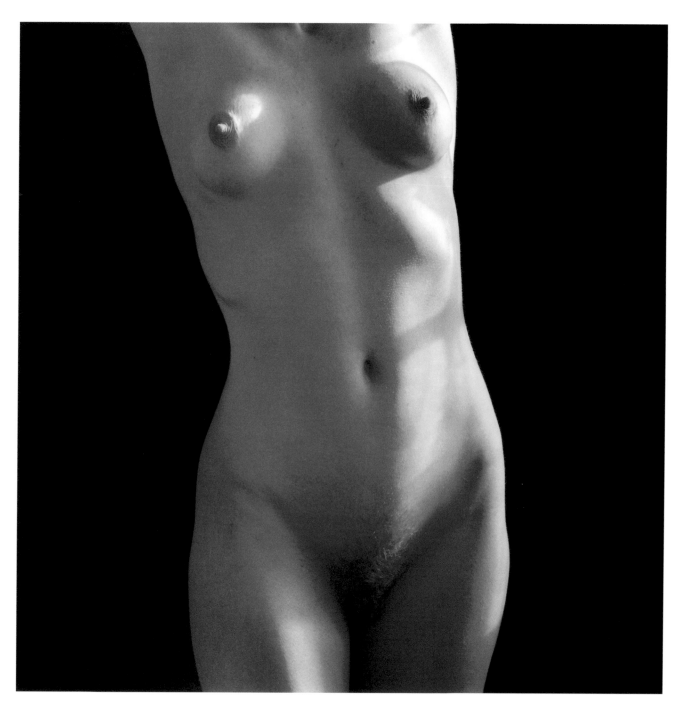

85

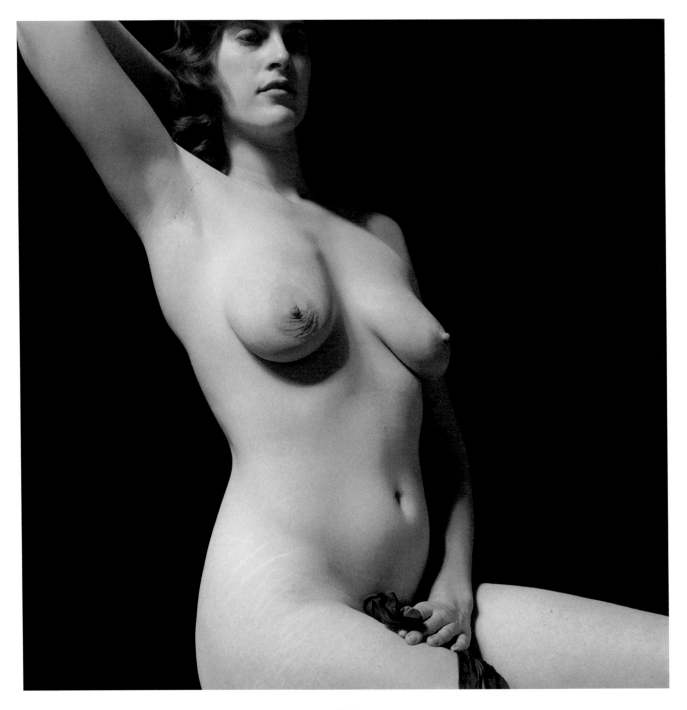

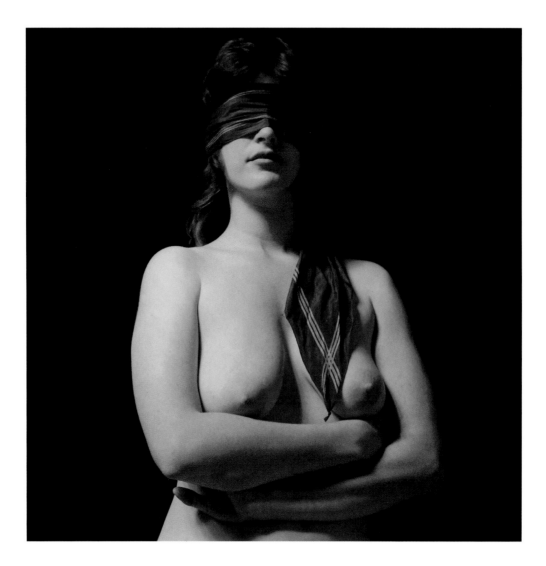

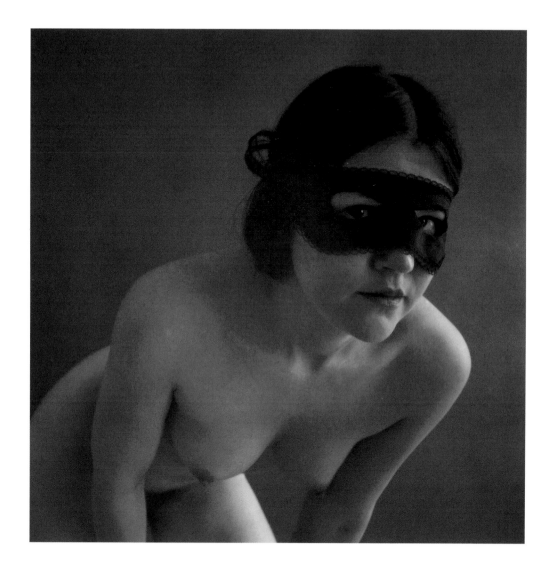

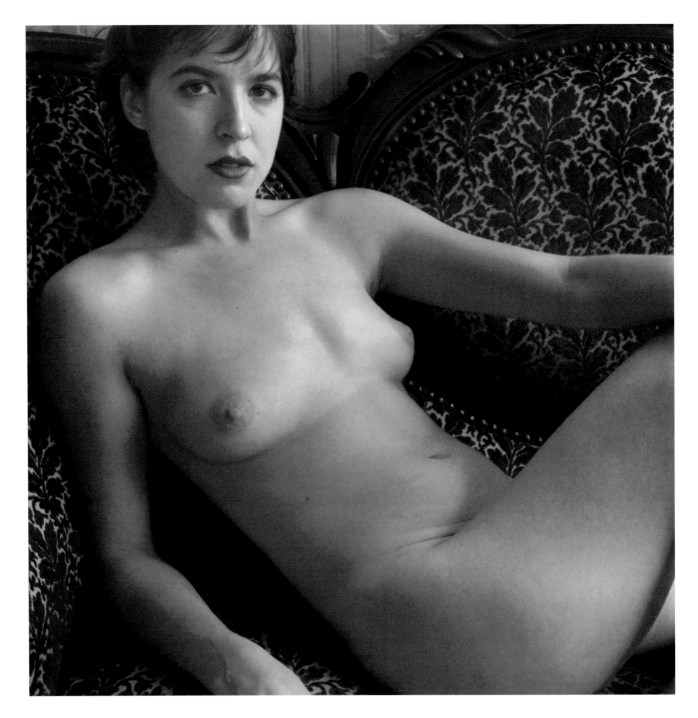

90

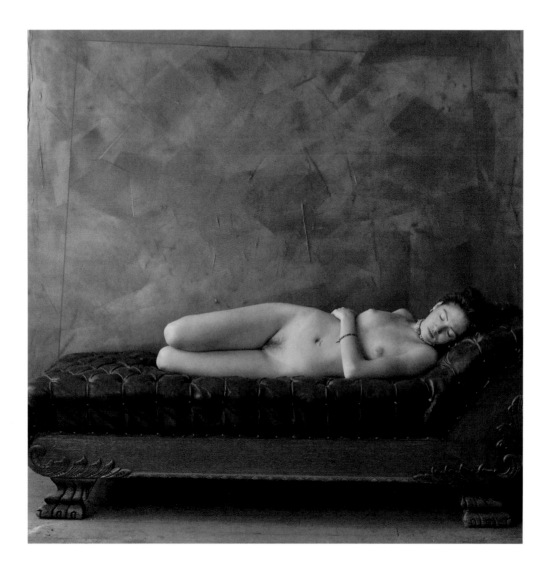

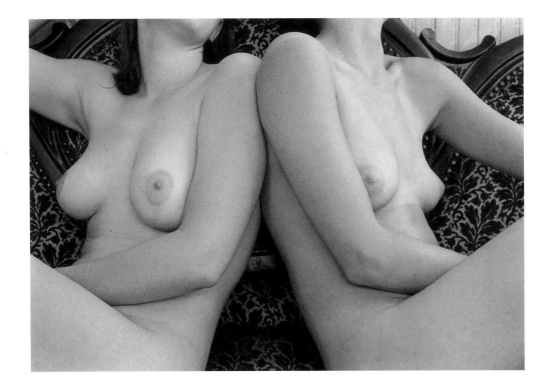

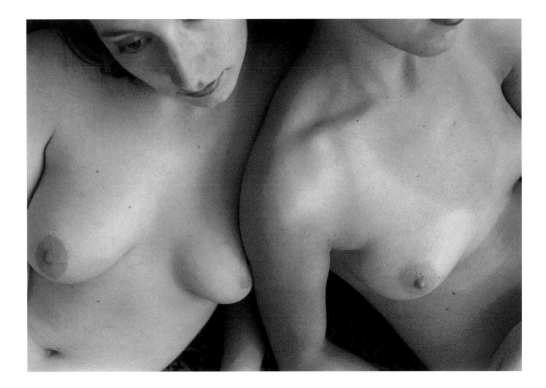

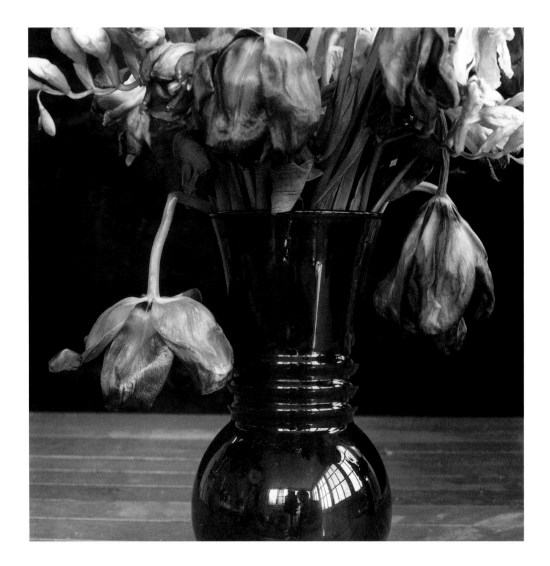

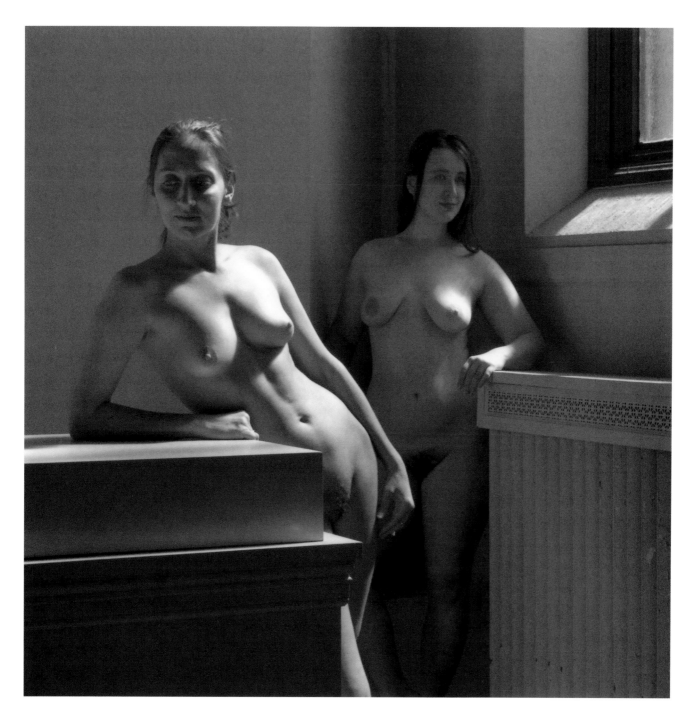

95

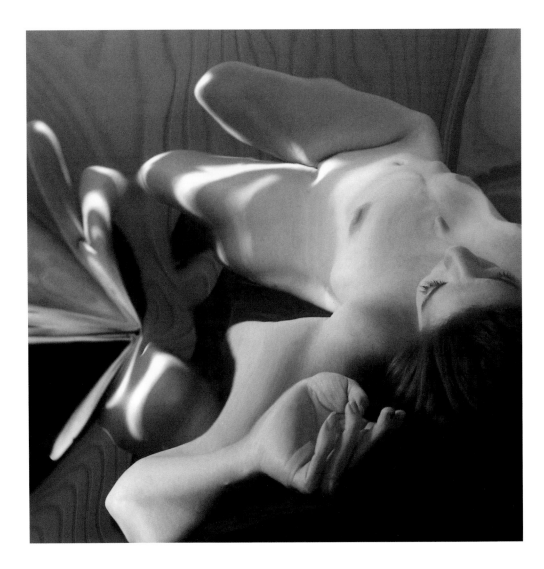

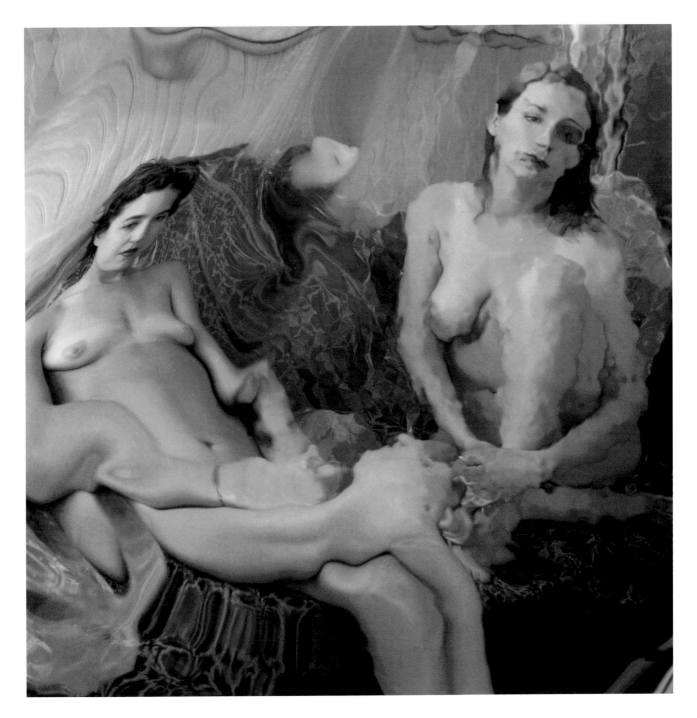

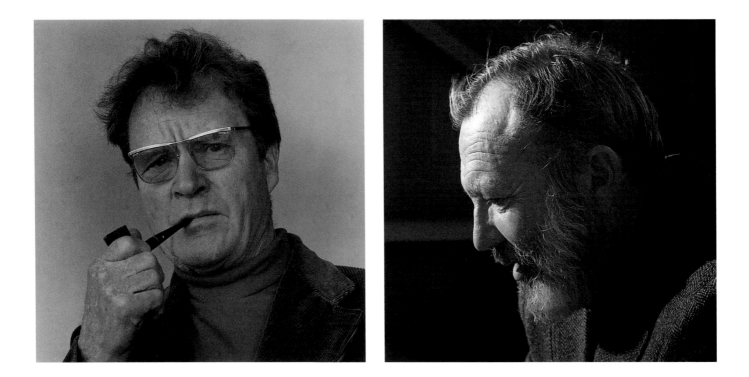

AFTERWORD

Ron Wohlauer

I love photography and the quirky way it can transform small rooms and hidden places into the magic world of my own creation. Although I have a few clues, I confess I have yet to discover just what attracts me to certain places or subjects. But I do know this: I am continually falling in love with the things I photograph both in or out of the studio. These days the studio is an upstairs sun porch in my house and it is, quite literally, a small room. More often than not, I am outdoors and working in the field. Elizabeth and I can put together a photographic trip at the drop of a hat. That usually means that we head west. Even when we travel east to Ireland or Scotland, when there, we head west. My compass is perpetually set to the west: The American West, the West Coast, the Southwest, the Pacific Northwest, the Western Isles of Scotland or the West of Ireland, in particular, County Donegal. I took from Edward Abbey the moniker of "sunset inspector" and I intend to fully exercise my job description.

Garrapata Beach. Ten miles south of Carmel, California. I am on my honeymoon and have brought my new bride, Elizabeth, to this amazing place. There are but a few days remaining in 1991 and I have just made the photograph that will become the cover of this book. The sea is wild and spectacular, the surf is deafening and a stiff wind carries salt spray to the headlands. The light defies verbal description. My footprints disappear along the water's edge as one booming comber follows another. As I walk along the very edge of North America, I am well aware of the many feet that have come this way before. I first came to Garrapata in 1972 and it was here that I laid down a deep tap root. Many forces brought me to this stretch of headlands, sand and

surf and there are profound reasons for my inner sense of radical amazement. Most important are the people who opened my eyes to the world around me and the the hidden places of my imagination.

I still have the pre World War II Zeiss Contax camera my father brought to the United States when he fled Nazi Germany in 1937. I grew up in a small town in northeastern Colorado where my father practiced medicine. Perhaps my fascination with the ocean stems from these early years spent in the midst of a vast sea of land. My father loved to travel and photograph and was never happier than when he was out in the land. His affection for these places was one of his legacies to me and I think of him often when I am in the field working.

Most of my college years were spent studying English history. My doctoral advisor at Clare College, Cambridge was a towering scholar and Tudor constitutional historian. At the time, I did not know that Sir Geoffrey Elton was, like my father, a refugee from the horrors of the Third Reich. I am quite sure that Elton never understood my taking a leave of absence to study photography. Yet, he unknowingly taught this aspiring photographer a great deal about art and craft. I learned to pay careful attention to detail and to allow myself to become absorbed with a sense of place. This special kind of being lost is, I believe, a special prerequisite for historians and photographers alike. You must become lost every once in a while in order to find where you are. And while I would never say that my work is historical, I am an ardent historian through and through.

Photography also has a history. Ansel Adams once remarked that it was amazing how far photography had come since its inception only to stay in the same place. Photography always seems to be in the throes of deep and chaotic change. It must be in the very nature of the beast, careening willy-nilly here and there, creating just enough great photographers and great photographs every now and then to make

us all stop and take notice. In the thirty or so years I have been work-
ing, there have been great changes in photography.

And I am not referring to cameras, film or any new process in-
cluding our own self proclaimed golden calf, the computer. When I
began, photography was much less precious and had much more to
do with the work you made rather than theories to explain why you
did, or better yet, why you did not.

I still vividly recall one Saturday morning in 1967 when I first
went into the darkroom. In this first, of many, small rooms, illumi-
nated by the orange glow of the safe light, I made my first print.

With a 25-cent Kodak pamphlet and I followed Mr. Eastman's
step-by-step directions. The print was much too dark, a second print
not much better but I was hooked. I had found my passion and now
had only to find my voice. That happily, can take a life time. I have
been extremely fortunate to fall into a pretty good crowd of fellow
travellers.

I trudge up the path to the waiting car weary and content, my
pockets full of freshly exposed film. Garrapata has been a frame of
reference for over twenty-five years and being here is always a home-
coming. My two photographic mentors had profound connections
with this place. Brett Weston came here often, made some of his finest
photographs and had once lived up the canyon. The prints from
Edward Weston's Fiftieth Anniversary Portfolio had been washed in
Garrapata Creek. Although Brett had moved to the Carmel Highlands
by the time I met him in the late Sixties, we came with cameras to
Garrapata many times. Morley Baer actually lived right here. The
monumental stone house still sits on the southern end of the head-
lands, overlooking the vast expanse of beach to the north. I made
many trips to the Monterey Peninsula during my student days at the
University of Oregon and always had a place to stay with either Brett

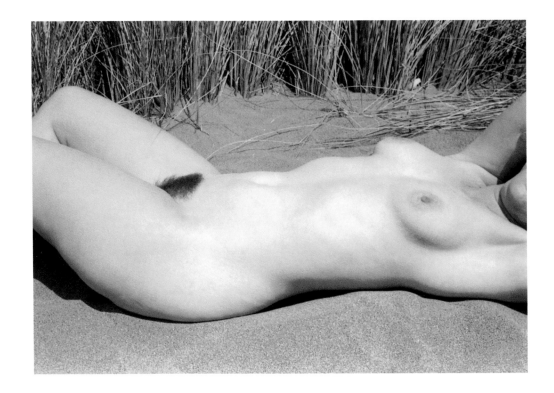

or Morley. They were two of the finest photographers I could ever hope to meet and they were warm friends.

Neither Brett nor Morley ever seemed like teachers but this eager student learned a lot. I saw what it meant to live a creative life and I kept my eyes and ears open. I looked at their photographs at every opportunity. I watched them work and they indulged me my many questions. Occasionally, I showed my prints and, once in a while, Brett would set one aside that he assayed as a "knock out." Most of all, I learned that beautiful work, no matter how dizzyingly elegant, was, more often than not, the product of great skill and hard disciplined effort. Although I feel that we wander the sandy reaches together, I sorely miss their company.

What I learned is this: In the small defined finite space of one life, photography has created limitless possibilities full of opportunities. It can take your breath away. I love what I do and can dream up almost any reason to visit Garrapata once again. In more audacious moments I claim not only the title of "sunset inspector" but also the Duke of Garrapata. I am a lucky man.

– Ronald W. Wohlauer

LIST OF PLATES

ACKNOWLEDGMENTS

This book would not have been possible without the generous support and assis-
tance of the following people. Jim Ray, a dear friend, has a thorough understanding
of my work and I often see my work through his eyes. Andrea Brown first tackled
the monumental challenge of giving this book some form and design. My mother,
Ruth Wohlauer, has from the beginning been a keen supporter of my photography.
I could not find a better publisher and friend than David Godine. Finally, Carl W.
Scarbrough put it all together and *Small Rooms & Hidden Places* mirrors his beautiful
sense of design and aesthetics. I thank you all. – R.W.

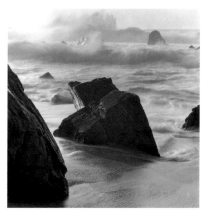

Winter Storm, *Garrapata Beach, California, 1992*

A NOTE ON THE TYPE

Small Rooms & Hidden Places has been set in Nofret, a type designed in 1986 by Gudrun Zapf von Hesse, an extraordinarily gifted typographer, calligrapher, and book binder. A very direct interpretation of its designer's galligraphic work, Nofret is graced by open letterforms, subtly tapered strokes, and an easy rhythm. The crisp and graceful italic is particularly noteworthy, and Nofret's several weights make it a commendable choice for both text and display settings. ::: *Design & composition by Carl W. Scarbrough*